Courageous

BEING A DAUGHTER
OF ZELOPHEHAD

NAAKI HADASSAH

COURAGEOUS
©2024, NAAKI HADASSAH

ISBN: 978 – 9988 – 3 – 8361 – 9

All rights reserved.

For any further information, contact the author on the following;
Mobile: +233 24 444 2273
Email: refinedinkconsult@gmail.com

DEDICATION

I dedicate this book to God Almighty and to
my son Albert Emmanuel Nana Boakye Asafu-
Adjaye.

ACKNOWLEDGEMENTS

Now praise we great and famous men, the fathers named in story.

I am grateful for the fathers that the Lord has blessed me with in my life's journey. I thank Apostle John Konadu for the opportunity to speak at the conference that birthed my inspiration for this piece.

I appreciate Apostle Lawrence Brown for his mentorship and guidance in my Christian journey. To my father Apostle Samuel Gyamfi I am grateful for the listening ear anytime I approach him.

Thank you so much Evangelist Addo for the direction and counsel. I can not forget Prophet

Dela Tofah for all the show of love and concern towards me. I acknowledge the love of Reverend Michael Adomako for all the spiritual support.

I save the best for last as I express my heartfelt gratitude to my mum, Eva Akuokor Nortey and my father Emmanuel Tettey Nortey, God has blessed you two so much and may He continue to bless you more. To my siblings David Nii Kpakpa Quartey, Naa Korkor Watson-Nortey and Mrs Maamle Watson Nelson, I appreciate your prayers.

CONTENT

FOREWORD

Rev. Isaac Gregory Amoah
Founder and Head Pastor
WordLife Transforming Church
/ President of Isaac G. Amoah
Ministries.

Mary Anne Radmacher Once said; Courage doesn't always roar. Sometimes courage is the quiet voice at the end of the day saying, *"I will try again tomorrow."*

This is why am so excited about this book, birthed from the life of an OVERCOMER. This book in my view is long overdue but it is better late than never.

Naaki Asafu-Adjaye, being a passionate student for women development and women living a purposeful life, has employed her skills of observation, analysis and experience in writing this book which comes after many years of living in two different parts of the world, that's; a developed nation (USA) and a developing nation (Ghana). And 1 love how both experiences was captured in who she has become today.

This book is aimed at opening the eyes of your understanding and equipping you, most especially as a modern-day daughter of God. The author shares from her personal experiences and from the Scriptures a profound revelation about the five daughters of Zelophehad who courageously not included pinned their names among the included.

The change of story steps Naaki Asafu-Adjaye outlined for the Modern-day daughter will cause a radical testimony in manifestation if practiced. The Modern-day daughter must be graceful, be strategic, be focused, be directed and be swift.

Which was inspired from the meaning of the names of the five daughters of Zelophehad.

I believe many lives will find this book motivating and helpful in possessing their possession possibly, as an author has, by the grace of God. I pray this book in your hand will include you among the rising Courageous women.

Apostle Samuel Gyamfi
(Fmr. Chairman) BETHEL
PRAYER MINISTRIES INT.

It is important to recognize that although several books have been written on women's rights, potentials, their general empowerment in different cultures and environments, this book focuses on Women taking their place, rights, and inheritance in a challenging socio-cultural and political environment. And even breaking the status quo, (divine order) as in the case of Zelophehad's daughters in *(Numbers 27:1-7).*

The writer tried to relate her joy of having both parents loving, caring, protecting and the encouragement she experienced. In contrast to the absence of such privileges in the lives of

Zelophehad's daughters. Which prompted them to rise to the occasion to take what belongs to them, irrespective of the challenges.

The writer points to the fact that, though one may not have what it takes to qualify for your inheritance, position, in this case (Gender) in an unfriendly culture, one should take consolation in the fact that our God rules in the affairs of humanity. Therefore, one must never stop fighting for his/her rights, counting on divine support (prayer).

These, divine experiences through Christ Jesus, should be a motivation to stand up for what one believes in. Moreso, she points out that the justice and fairness of God should give one the impetus and the energies to pursue God-given goals and objectives. Even, in hostile environments, irrespective of one's gender.

This book presents difficult and often scattered ideas and concepts in the most progressive, current and user-driven manner, whilst at the same time maintaining its spiritual rigor.

Especially, the application of the names of Zelophehad's daughters. (move, walk, run, etc.) makes the concepts very relevant in every human pursuit of happiness, goals and purposes in life endeavors with an unlimited vigor.

Finally, this book demonstrates in a rigorous manner the relevance of studying the possession, standing up to socio-cultural and political limitations and institutions in a dynamic frontier of women's empowerment with the resilience in rising up to their institutional challenges or limitations to the rights of their God-given privileges.

I recommend it for all to read as it relates to our daily living in every environment. God bless you.

Prophet Dela Tofah
Author, Founding President
Christ Rivers -The Blessing
Hub

Women played a major role in the redemptive plan of God and will continue even to the Ages to come. As powerful as God is, He needed a woman to serve as a portal to the Earth that He once created in order to redeem man.

Unfortunately, many women of our generation today have lost touch with their divine roles in the collective plan and wisdom of God.

This book, Courageous is a clarion call for women to revert to their divine roles as designed by God. It seeks to stir up and birth the virtues of courage, focus and determination in women, so as to be able to change the narrative.

This book has been birthed from the place of prayer and experience, and you will undoubtedly be blessed reading it.

My ultimate prayer for you is that every seed of divine revelation meant for you in this book will bring you unprecedented harvest of God's goodness, Blessings and more.

Apostle Kwabena Offei Asah
Founder of Rhema of God
International Ministries USA

To all wonderful readers of this awesome piece, my name is Apostle Kwabena Offei Asah, I am the founder and leader of Rhema of God International Ministries USA.

The Lord be with you my daughter in Christ Naa Asafu-Adjaye for writing this book. I know the Lord has spoken so there is more to come. God bless you.

Chapter One

LET'S TALK ABOUT ME A LITTLE

Earlier

I was born in the early seventies. For those who were born around that year in Ghana, we can recall a period of famine and scarcity of farm produce. Those times, uncooked food which was not ready for consumption got sold before it got ready for consumption. As a young girl, I was fortunate to experience the love of both parents. I was trained in the fear and love of God. For a very

long time, I got to enjoy special affection and love from both parent because I was the first girl of my parent.

I was baptized into the Methodist Church, Ghana and my father was then a chorister in one of the most popular societies of the Methodist Church. I loved the hymns and I still do. I can still hear the tunes of some of these hymns in my past times.

I got to experience the selfless love of a mother as well as that of a father in different ways. I remember how my father threw me out of a window whilst the vehicle on which we were travelling started smoking. He thought of saving me first before anything else. Thankfully, I landed well but I sacrificed my front teeth in the process. The good thing about that was me being saved from burning in that fire and sure, my teeth were back in no time. And oh! My father was saved too. Thanks be to God.

My looks described the love of a mother. She made sure I always appeared like a princess.

The surprising thing is that, we were not overly rich, but she always made sure that we appeared stunning wherever we went. And this started with me. I confidently post my childhood pictures and admire how far my mother went to adorn me always.

Mid-life

In the midst of life's experiences, I had my fair share of formal education. I was a product of the 'O' and 'A' Level Education system. Education took me round some regions in Ghana. I had the 'O' Level in Winneba and then came back to Accra. As the system directs young people in Ghana, I had National Service and subsequently, I started working.

One would say that, this narration appears rosy and event free. However, I glory in the saving power and mercy of God upon my life. There were times during my days at school in Winneba, when I would always be brought home during examination periods. I would fall sick to the extent that one would think that would be my end. The routine visits to the house during

examination periods because I was unwell was so persistent. It got so disturbing to my parent. At a point that infirmity of unknown yet burdening sickness also passed. As it would be, it left as it came. The Lord is faithful.

Now

I had always wanted to travel. When I was ripe for marriage, I was blessed with marriage that took me outside Ghana, the United States of America. It was and still is a dream come true. In the USA, I had my share of the culture shock and it was expected.

A Ghanaian proverb says, the eyes of the stranger are wide open yet he sees nothing. And I could see nothing, but now I see everything. I learnt with experience and through little or no guidance to take hold of my portion of 'land' apportioned for me in a strange land.

I knew I had an inheritance, I knew I could possess, I knew I wanted it badly but how do I negotiate my portion of this land in a strange place.

The land I am searching is not what one would refer as that which is used for building projects or farming and so on but a land in terms of my identity.

An identity that makes me part of a people, an identity that brings ease, an identity that makes me soar without boundaries. An identity that makes me accepted wherever I go. I got inspired when I read about the Daughters of Zelophehad. So, when I was invited to speak at the conference, and the theme was on the Daughters of Zelophehad, I saw it as a dream come true. The reason is that, I align with their story.

Thankfully, my father is alive, my mother as well but I have been alone in the US. For the purpose of this piece and present times, a daughter of Zelophehad is a lady who is solo despite all odds. This daughter may not be orphaned, may be married, may be divorced but exists alone in her thoughts, ideologies, faith, dreams and aspirations for her future. This is my inspiration.

Chapter Two

WHO WAS ZELOPHEHAD?

The Preamble

Numbers 27:1-7 presents a scenario where women were not allowed to own lands. In fact, in Israel a woman was treated like the property of her father, and was then transferred to her husband via a bridal payment. In their humility and wisdom, the five daughters of Zelophehad influenced the making of a new law by God to allow women to own lands.

As the Israelites prepared to enter the Promised Land at the end of their escape from Egypt, Zelophehad's daughters lived. A fresh census was required as the people shifted and time passed in the desert *(Numbers 26:1-4)*. This was done to aid in the planning of the new country's social and economic systems. According to God, the tribes were to get lands according to the size of their families *(Numbers 26:52-56)*. Every male head of the home was given a certain amount.

Without a son, Zelophehad had passed away. His daughters took an unprecedented action when they discovered their father's name would not be included when the estate was divided up because there was no male successor.

They requested their right to inherit their father's estate from Moses, Eleazar the priest, the leaders, and the assembly as a whole. Moses took the issue before God in humility. In response, God said that the daughters' request was reasonable and that they ought to receive their father's fortune.

God is fair and just, and He does not desire for women to face discrimination. He believes they are well capable of being landowners and property managers.

This may sound and appear simple. It appears that the daughters made their request once and it was granted but note these daughters had to persist and make a continuous move. It was becoming burdening for Moses and that was the reason he took it to God.

Just like how Cain had to carry the burden of guilt and sin for killing his brother Abel, these daughters nearly inherited the repercussion of their father's inability to give birth to a son. They arrived at the Promised Land but nearly ended up without an inheritance.

NKJV Genesis 27:40
"By your sword you shall live, And you shall serve your brother; And it shall come to pass, when you become restless, That you shall break his yoke from your neck."

This was God's promise to Esau that despite the yoke of sin upon him, when he becomes restless, he shall be able to break that yoke. Did the daughters have a yoke too? Your guess is as good as mine, they did. The yoke of losing their father before arriving on the Promised Land was the first.

Second was that, their father was unable to leave a heir, thus a son to inherit his share of the land and third, these daughters were unmarried. Their issue was almost becoming a hopeless and fruitless situation.

Chapter Three

HOW WOMEN WERE PORTRAYED IN THE BIBLE

Women in the Bible performed different roles. Some women supported their communities like Rahab who shielded the spies. Some women were serviceable like Ruth who never let go of her mother-in-law.

Some women betrayed their men like how Delilah betrayed Samson. Some women also

worshipped selflessly like the prostitute who used her tears to wash the feet of Jesus before his crucifixion. Above all women were the first to announce the resurrection of the Lord Christ after he rose on the third day. These are but a few of the representation of some women that scripture captures.

As an African, I have witnessed and heard of stories and scenarios that led individuals especially women to lose their share of properties or opportunities just by being a woman. It is most heard of, how women are laid down in the society because they are unmarried. It is seen how most women are maltreated because of childlessness.

Sometimes even the male counterparts are less guilty than the fellow females in the society. Is it strange to mention how quickly tradition holds the woman accountable during the loss of her husband? Many instances in our communities in the past and even now serve as evidence of how the woman is deprived of her share even when she merits it.

Despite all odds these daughters still moved without knowing what their fate would reap, they persisted and moved regardless. I then questioned how they made every effort to move and they did it strategically. Their attitude and resilience lied in an identity they bore- their names.

This brought me to a point that the names have influence and great effect. This has been said many times and may sound like a cliché but then, let us look at the names of the daughters.

Chapter Four

THE STRENGTH IN A NAME

Most of the time, people give names based on experience with nature, people or by inspiration. Zelophehad's daughter's names are significant.

They were born and named to be active agents of change. Their names *Mahlah, Noah, Hoglah, Milcah,* and *Tirzah.* A look into their names gives an indication that truly, names have significance

and influence on the bearers. Let's look at the names of the daughters and what they denote.

Mahlah – Like the Hebrew verb, Le-Cholel which means to move (and dance in modern Hebrew).

Noah – like the Hebrew verb, La Nua which means to move as well.

Hoglah – like the Hebrew verb, La Chug which means to circle.

Milcah – like the Hebrew verb, la-Lechet which means to walk.

Tirzah – like the Hebrew verb, La Rutz which means to run.

As you probably noticed, they all have something to do with the concepts of moving naturally but in Hebrew. All these verbs are also connected to the concept of initiating or simply 'being active' and that was precisely what the daughters of Zelophehad symbolized.

NKJV Numbers 27:1

"Then came the daughters of Zelophchad the son of Hepher, the son of Gilead, the son of Machir, the son of Manasseh, from the families of Manasseh the son of Joseph; and these were the names of his daughters: Mahlah, Noah, Hoglah, Milcah, and Tirzah."

Scripture says in the above that they came, as in they moved. In other words, they tried to pursue their dream. As a Christian, I must admit that there have been situations that demanded my action but I did not push harder. Although I no longer let situations hold me down anymore, the story has encouraged me that, making a move towards achieving your desires is not vain.

The first two names thus Mahlah and Noah are similar in meaning thus to make a move. One can make a move either in the positive or negative directions. Hoglah appeared as a conqueror for when an enemy surround you, it is unlikely for its victim to survive. Milcah means to walk as earlier stated above. Whether the walk is slow or brisk it still denotes movement towards a certain

goal. And last but not least is Tirzah which means to run. To run is symbolic to strength, hope, perseverance, patience, encouragement and faith. An athlete in a race looks ahead for the prize despite the tiredness he faces on the field.

For years, if not months, he trains to build endurance for the final day. He builds hope of winning on the final day. As he builds hope he nurtures patience by encouraging himself for the day of winning.

NJKV Numbers 27:2
"And they stood before Moses, before Eleazar the priest, and before the leaders and all the congregation, by the doorway of the tabernacle of meeting, saying..."

When they finally stand before their elders they put their request before the elders. One other significant thing was the fact that, the daughters exonerated themselves from the sin of their father. In fact, they admitted that their father had died in his sin. So fascinating to know how they are honest in their negotiations. They agree

that they stand open with nothing to hide and all that they demand is their share of the land. In aggression and determination, they question the elders to release their portion.

NKJV Numbers 27:3-4

"Our father died in the wilderness; but he was not in the company of those who gathered together against the Lord, in company with Korah, but he died in his own sin; and he had no sons. Why should the name of our father be removed[a] from among his family because he had no son? Give us a [b]possession among our father's brothers."

HOW CAN ONE APPROACH GOD

Holy aggression

The daughters knew their rights and demanded accordingly. Moses was unsure of their request so he consulted God. I had thoughts that Moses had never seen such courage and aggression from women demanding their rights. I would say he had doubts but he did not want to have the final say concerning the request of the daughters.

NKJV Numbers 27:6-11

So, Moses brought their case before the Lord.

⁶ And the Lord spoke to Moses, saying: ⁷ "The daughters of Zelophehad speak what is right; you shall surely give them a possession of inheritance among their father's brothers, and cause the inheritance of their father to pass to them. ⁸ And you shall speak to the children of Israel, saying: 'If a man dies and has no son, then you shall cause his inheritance to pass to his daughter. ⁹ If he has no daughter, then you shall give his inheritance to his brothers. ¹⁰ If he has no brothers, then you shall give his inheritance to his father's brothers. ¹¹ And if his father has no brothers, then you shall give his inheritance to the relative closest to him in his family, and he shall possess it.'" And it shall be to the children of Israel a statute of judgment, just as the Lord commanded Moses."

Most of the time, our requests appear too much to us when we ask God. It appears our motive for asking is for selfish reasons. So, in the scripture below, we are told the reasons for which we hardly receive what we ask for.

NKJV James 4:3
"You ask and do not receive, because you ask amiss,
that you may spend it on your pleasures"

Most of the time, we ask for blessings for selfish reasons. Genuinely, these daughters of Zelophehad needed the land for their survival. When Hannah added the clause of giving Isaac to God as a sacrifice, her long awaited blessing manifested. The resilience of the daughters to move, circle, walk and run for their inheritance paid off.

It touched the heart of God to make a decree that would change how inheritance will be shared among generations to come; should they face a problem like how the daughters of Zelophehad experienced.

Subtle but focused desperation

Again, I could tell the desperation in the hearts of these daughters. They were unmarried and they stood alone. But in their desperation, they approached the right quarters. They went to

Moses directly. How often do we go about telling our problems to individuals who can hardy offer listening ears, let alone to help us? Though they were desperate, they were focused in their dealings.

They were focused on attracting God's attention and they succeeded by doing so through Moses.

NKJV Numbers 27:6-11
So, Moses brought their case before the Lord.
They were focused and strategically positioned to receive answers to their request. They had to initiate the process by moving. I have learnt that to be strategically positioned is to persevere at the place of prayer. To wait for the manifestation of the breakthrough. So after their request to receive their father's portion of the land, they wait in expectancy for positive results.

Chapter Six

WOMAN, THOU ART LOOSED!

The theme of the conference that birthed my inspiration was 'Woman thou art loosed'.

At the conference, the story of the daughters of Zelophehad was my reference point apart from the conference themed text from *Luke 13:11-13*.

From the discussions so far, I can say that, I have mentioned how the daughters negotiated their

right by navigating through the rules laid down for inheritance then.

NKJV Luke 13:11,12,13
"And behold, there was a woman who had a spirit of infirmity eighteen years, and was bent over and could in no way raise herself up. But when Jesus saw her, He called her to Him and said to her, "Woman, you are loosed from your infirmity."

When in the text above, Jesus declared to the woman, 'Woman thou art loosed,' he meant a whole lot than just being set free from an infirmity. For a woman like me in this present generation, I consider several situations which has led to my freedom. I refer to different instances when I was loosed from an infirmity.

This infirmity may not be similar to the woman in *Luke 13*. As someone reading these lines, I could tell that, you also have situations in your life which you can relate to the story in *Luke 13*. Being loosed from societal oppression is also freedom.

One can testify how societal norms and conventions entangle individuals. For several reason, some which may not be mentioned, some of these societal norms make individuals feel less of a human. A philosopher once said, ' no human is an island.' In the same way, once we live and mingle with other people in the society, their choices, rules and conventions affect us either negatively, positively or both.

The referents, thus the daughters of Zelophehad had their own forms of societal entanglement. They were entangled in web of losing everything because of marital conventions. For them, they loosened themselves before their plea was considered.

The mere fact that they decided to approach the elders and demand their share of inheritance was a major step to freedom. They were loosed! That meant other people who found themselves in the same situation would be loosed as well. They cleared the path for generations behind them. A positive thing I learnt from this is that, there can

be generational freedom as well. There can never exist only generational negativity. Manye Naaki (mention your name), I am loosed!

Life circumstances led me and my son to move out of my matrimonial home. After settling in a new apartment, we encountered a few issues with the landlord. What did he not do? He made advances towards me because I'm a single mother but I turned blind eyes to all that because I am loosed to not settle for less. He changed locks of our apartment without our knowledge. He'd enter into our space unannounced. He called Social Workers on us. He did all that he could just to frustrate me and my son. Guess what, when you are loosed, set free, separated, severed, set apart only those who know your situation will see you as extraordinary.

For a fact, these experiences were painful and burdening but God came through. Finally, we moved out of his house a few months later.

I can say confidently that, these situations gave me strength renewed each day. I was loosed so I

could tell these stories of my life to encourage and strengthen others. She was set free to go and free others. We are loosed to lift those whose heads are bowed due to life's experiences. It will interest us all to know that the line 'woman thou art loosed' has been a source of inspiration to the Christian family.

Musicians and filmmakers have used it as their theme in music and film production. A practical example is the 2004 American drama film Woman Thou Art Loosed was written and directed by Stan Foster and produced by Reuben Cannon. It is based on the self-help book by T. D. Jakes and marks Schultz's 44th film or television series.

In the movie, a young woman must confront her lengthy past of drug misuse, sexual assault, and poverty. The plot was reportedly partially inspired by the screenwriter's previous romance with a college girlfriend. The movie was preceded by a gospel stage production that Tyler Perry wrote, produced, and directed.

This practical example shows that, an infirmity comes in different ways. The emotional torture, the burden of a failed marriage, the thought of childlessness, the embarrassment that is associated with being single among some communities et cetera.

These and more, give an indication that individuals will be content when some desires of their heart are provided at last. To the daughters of Zelophehad, it was the portion of their father's inheritance which finally summed up that they have been considered and counted among the beneficiaries of the Promised Land.

Chapter Seven

HOW DO I GET LOOSED?

Based on what I've shared;

- I was loosed from the negative influences of those experiences by preserving at the place of prayer. A man of God once said, *"the best time to pray is when you don't feel like praying"*.

~ Keep your prayer altar burning.

~ If anything stops in your life, don't let it be prayer.

~ Bible states that, pray without ceasing.
 1 Thessa 5:17

* I showed up consistently at work with a very positive demeanor.

* I was loosed from all the emotions that should have broken me down.

For instance, my landlord abused me and my son emotionally. He became angry and called me and my son out of our names. He used abusive words on us. He threatened to evict us for reason best known to him. There were police officers once every week to ensure that my son and I were safe.

This weighed us down emotional as time went on, his hatred towards us escalated. Just imagine how frustrating the experience can be... How traumatized I was but I had to loosen myself for the sanity of my son. The strength I developed was nurtured at the place of prayer where I petitioned God for my share of peace and solace.

At that point, my negotiation rested on finding my inheritance of tranquility. God did! I grew, I am still growing.

My landlord was still relentless. He recruited people to hate us. He went as far as calling DPSS to take my son away from me. (DPSS- children welfare abuse mothers homeless). You know what the outcome would have been, for those who live in the US. After about 20-25 minutes of interview with my son, the social worker declared the call useless and we were exonerated. Praise be to God. When you are loosed, the enemy may even use legal means to pin you down but remember, you are loosed! The rules will not be meaningful anymore; the rules will be adjusted for you to be free.

Does it look like the daughters of Zelophehad situation? Your guess is as good as mine. When the elders, such as Moses, only knew about the old rules, the Almighty God, rendered the old rule baseless and changed it to suit the daughters.

Because I did not hide as a result of my struggles, God gave me destiny helpers who stood by my side throughout those difficult times until we moved out of the house.

Chapter Eight

BECOMING A MODERN-DAY DAUGHTER OF ZELOPHEHAD

1. Dance- Be graceful

As a modern-daughter, adorn yourself with grace. Just like the name of the first daughter, be graceful like one who is being admired because of how she dances. Maintain a calm disposition in all you do.

Be calm but strong inside. It takes one to dance gracefully. It needs rhythm and pace otherwise the dance may appear funny and the dancer may be ridiculed. So in the midst of everything chaotic, maintain calm but be graceful.

2. Move- be strategic

As a Christian, we are admonished to be strategic. Several texts from scriptures teach us to be strategic.

Proverbs 24:3-4 NKJV

"Through wisdom a house is built, And by understanding it is established; By knowledge the rooms are filled With all precious and pleasant riches"

Proverbs 16:8-9 NKJV

"Better is a little with righteousness, Than vast revenues without justice. A man's heart plans his way, But the Lord directs his steps"

Colossians 3:23-24 NKJV

"And whatever you do, do it heartily, as to the Lord and not to men, knowing that from the Lord you will

receive the reward of the inheritance; for[a] you serve the Lord Christ."

Jeremiah 29:11 NKJV
"For I know the thoughts that I think toward you, says the Lord, thoughts of peace and not of evil, to give you a future and a hope."

Of all the scripture quoted above, I find strategic confidence in **Jeremiah 29:11**. To me, whatever experience I went through was meant to make me Courageous. That is how I developed the title of my book. The Lord knew that those experiences, no matter how painful and sour, once I went through it successfully, I have been made tougher and courageous.

3. Circle- be focused
Whilst narrating how I overcame and got loosed, I mentioned my persistent tarrying at the place of prayer. My focus was on the crown.

For the purpose of my situation, my crown was to be loosed to inherit the peace and tranquility

that I crave in the Lord. My focus on God whilst I waited and prayed, yielded my freedom.

4. Walk- be directed
The focus then led to a well-directed walk with Christ. Like the daughters of Zelophehad, I walked with a directed God given purpose. Through daily prayer and guidance from my fathers, I learned to be led and loosed from other hidden weights in my life.

5. Run- be swift
It is evident in the text concerning the daughters of Zelophehad and how swift they were in the approach to requesting their share of their father's inheritance. After we have learnt to be graceful, strategic, focused and directed, it gets to period where we need to run. Thus, to make a move. In all, I consider how after envisaging my desires of being free, a little move led me to my God ordained helpers.

I learnt that, as a modern-day daughter, experiences and societal norms does the following:

- It can build you up positively or break you down.

- It can encourage you or make you lose your self-worth.

- It can make you go into hiding.

- It can make you give up.

- It can make you preserve and tarry at the place of prayer so you can break loose from your bondage/shackles or it can make you stop praying especially when you do not see changes in your situation.

Nevertheless, it is clear which line to tow when I am faced with such challenges. The five step of dance, move, circle, walk and run.

PRAYER POINTS:

Everyone has had an experience, some unforgettable;

a. Pray for strength to forget that negative outcome of your experience.

b. Pray for God's wisdom to identify the good that came out of that bitter experience (patience developed).

c. Pray for complete restoration of everything you lost whilst you were going through that bitter experience.

d. As change agents, may your face be seen when we are on duty. As I perform my duties, may God alone be seen.

BIBLIOGRAPHY

i. www.biblegateway.com

ii. www.clearlyreformed.org

iii. www.hebrewversity.com

iv. www.truthunity.net

v. www.religionandgender.org

GALLERY

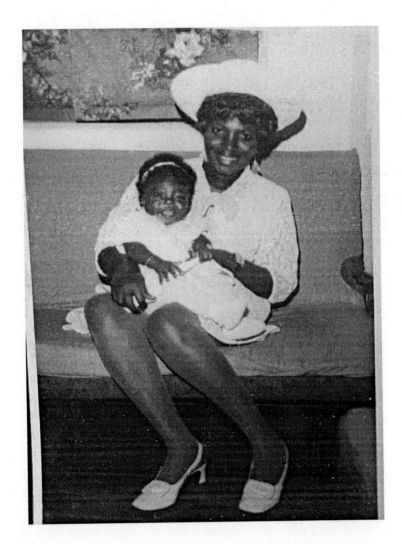

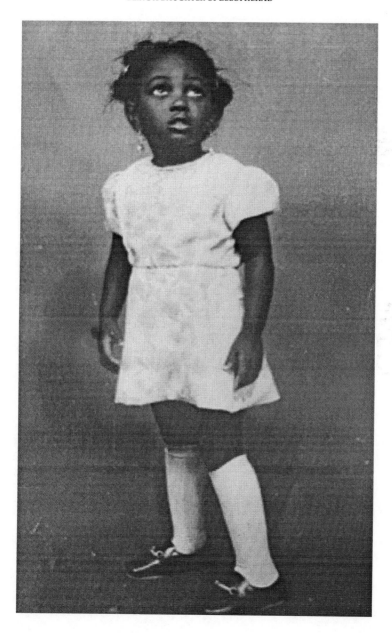

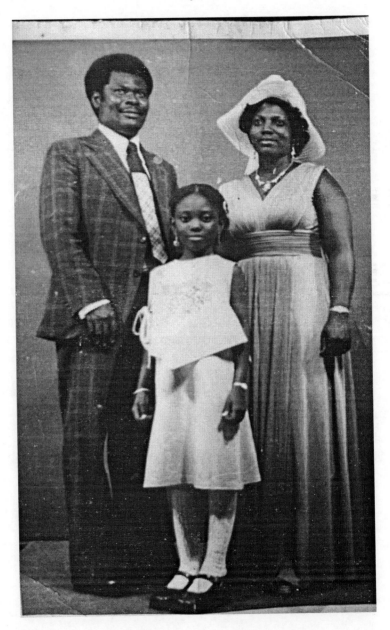